*				
		in the second		
	•			

Dinosaurs and Other Prehistoric Animals

The Step-by-Step Way to Draw Tyrannosauruses, Woolly Mammoths, and Many More...

BOOKS IN THIS SERIES

- Draw 50 Airplanes, Aircraft, and Spacecraft
- · Draw 50 Aliens
- · Draw 50 Animal 'Toons
- · Draw 50 Animals
- · Draw 50 Athletes
- · Draw 50 Baby Animals
- · Draw 50 Beasties
- · Draw 50 Birds
- · Draw 50 Boats, Ships, Trucks, and Trains
- Draw 50 Buildings and Other Structures
- Draw 50 Cars, Trucks, and Motorcycles
- · Draw 50 Cats
- Draw 50 Creepy Crawlies
- Draw 50 Dinosaurs and Other Prehistoric Animals
- Draw 50 Dogs
- · Draw 50 Endangered Animals
- Draw 50 Famous Cartoons
- Draw 50 Flowers, Trees, and Other Plants
- · Draw 50 Horses
- Draw 50 Magical Creatures
- Draw 50 Monsters
- · Draw 50 People
- · Draw 50 Princesses
- · Draw 50 Sharks, Whales, and Other Sea Creatures
- · Draw 50 Vehicles
- Draw the Draw 50 Way

Dinosaurs and Other Prehistoric Animals

The Step-by-Step Way to Draw Tyrannosauruses, Woolly Mammoths, and Many More . . .

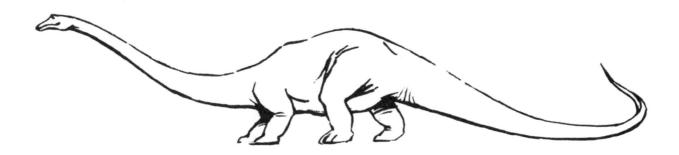

Norwell Public Library

LEE J. AMES

With a Foreword by Georg Zappler, Former Director, Staten Island Zoological Society

Copyright © 1977 by Jocelyn S. Ames

All rights reserved.

Published in the United States by Watson-Guptill Publications, an imprint of the Crown Publishing Group, a division of Random House Inc., New York, in 2012.

WATSON-GUPTILL and the WG and Horse designs are registered trademarks of Random House, Inc.

Originally published in hardcover in the United States by Doubleday, a division of Random House Inc., New York, in 1977.

The Library of Congress has cataloged the first printing of this title as follows:

Ames, Lee J.

Draw 50 dinosaurs and other prehistoric animals. Lee J. Ames: with a foreword by Georg Zappler.—1st ed.—Garden City, N.Y. Doubleday, c1977.

[63]p.:ill.; 32 cm.

SUMMARY: Step-by-step instructions for drawing fifty different dinosaurs and other prehistoric animals.

1. Dinosauria in art. 2. Extinct animals in art. 3. Animal paintings and illustration [1. Animal paintings and illustrations. 2. Drawing-Technique]

I. Title.

NC780.A482 743'.6

MARC

Library of Congress

77[7712] AC

76007285

ISBN 978-0-8230-8574-3 eISBN 978-0-7704-3289-8

Printed in the United States of America

10 9 8 7 6 5 4 3 2 1

Foreword

Mr. Ames has designed a fascinating and instructive book. Young readers and adult students will be able to gain an appreciation of many of nature's now extinct life forms. But, more importantly, they will be able to re-create for themselves the kinds of animals that swam the seas, walked the land and soared through the air in ages long past. Some of these creatures were the ancestors of now living forms, others were only temporarily successful and disappeared without issue. Ponderous woolly mammoths, plated and horned dinosaurs, spiny sharks, flightless birds, membranewinged reptiles, seagoing lizards, gigantic camels, saber-toothed cats and giant swimming scorpions all come to life again by way of step-by-step, easy-tofollow instructions. And, although the drawing sequences are very basic and simple, the final results yield scientifically accurate fleshed-out representations of animals known only from their fossil remains. In order to arrive at his reconstructions, the artist has drawn on over a hundred years of scientific research by paleontologists from all over the world. Mr. Ames is to be commended for making the world of prehistoric life accessible to everyone.

GEORG ZAPPLER

Former Director, Staten Island Zoological Society

To the Reader

This book will show you a way to draw prehistoric animals. You need not start with the first illustration. Choose whichever you wish. When you have decided, follow the step-by-step method shown. Very lightly and carefully, sketch out the step number one. However, this step, which is the easiest, should be done most carefully. Step number two is added right to step number one, also lightly and also very carefully. Step number three is sketched right on top of numbers one and two. Continue this way to the last step.

It may seem strange to ask you to be extra careful when you are drawing what seem to be the easiest first steps, but this is most important, for a careless mistake at the beginning may spoil the whole picture at the end. As you sketch out each step, watch the spaces between the lines, as well as the lines, and see that they are the same. After each step, you may want to lighten your work by pressing it with a kneaded eraser (available at art supply stores).

When you have finished, you may want to redo the final step in India ink with a fine brush or pen. When the ink is dry, use the kneaded eraser to clean off the pencil lines. The eraser will not affect the India ink.

Here are some suggestions: In the first few steps, even when all seems quite correct, you might do well to hold your work up to a mirror. Sometimes the mirror shows that you've twisted the drawing off to one side without being aware of it. At first you may find it difficult to draw the egg shapes, or ball shapes, or sausage shapes, or just to make the pencil go where you wish. Don't be discouraged. The more you practice, the more you will develop control. Use a compass if you wish; professional artists do! The only equipment you'll need will be a medium or soft pencil, paper, the kneaded eraser and, if you wish, a compass, pen or brush.

The first steps in this book are shown darker than necessary so that they can be clearly seen. (Keep your work very light.)

Remember there are many other ways and methods to make drawings. This book shows just one method. Why don't you seek out other ways from teachers, from libraries and, most importantly . . . from inside yourself?

Lee J. Ames

To the Parent or Teacher

"David can draw a dinosaur better than anybody else!" Such peer acclaim and encouragement generate incentive. Contemporary methods of art instruction (freedom of expression, experimentation, self-evaluation of competence and growth) provide a vigorous, fresh-air approach for which we must all be grateful.

New ideas need not, however, totally exclude the old. One such is the "follow me, step-by-step" approach. In my young learning days this method was so common, and frequently so exclusive, that the student became nothing more than a pantographic extension of the teacher. In those days it was excessively overworked.

This does not mean that the young hand is never to be guided. Rather, specific guiding is fundamental. Step-by-step guiding that produces satisfactory results is valuable even when the means of accomplishment are not fully understood by the student.

The novice with a musical instrument is frequently taught to play simple melodies as quickly as possible, well before he learns the most elemental scratchings at the surface of music theory. The resultant self-satisfaction, pride in accomplishment, can be a significant means of providing motivation. And all from mimicking an instructor's "Doas-I-do. . . ."

Mimicry is prerequisite for developing creativity. We learn the use of our tools by mimicry. Then we can use those tools for creativity. To this end I would offer the budding artist the opportunity to memorize or mimic (rotelike, if you wish) the making of "pictures." "Pictures" he has been eager to be able to draw.

The use of this book should be available to anyone who wants to try another way of flapping his wings. Perhaps he will then get off the ground when his friend says, "David can draw a dinosaur better than anybody else!"

Lee J. Ames

Draw 50 Dinosaurs and other Prehistoric Animals

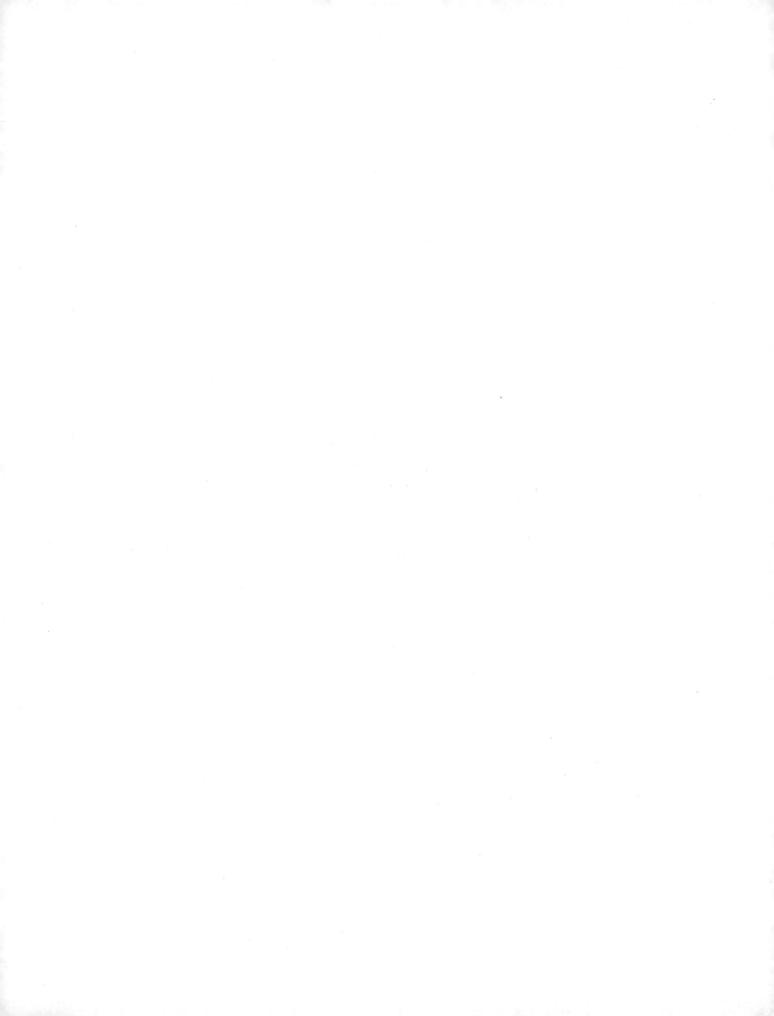

TYRANNOSAURUS 50 feet long A Giant Meat-eating Dinosaur

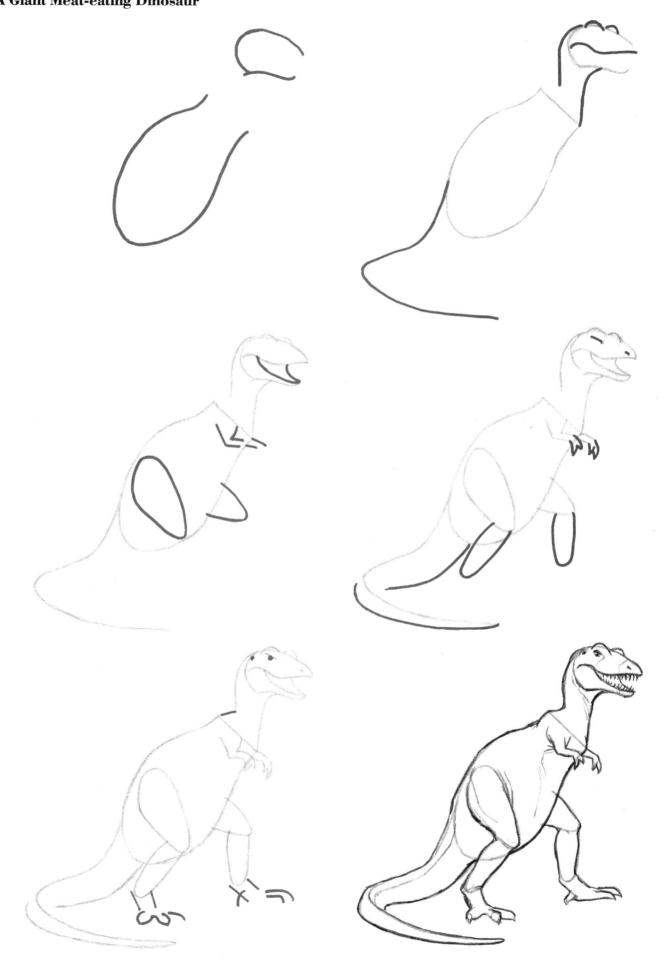

APATOSAURUS (formerly BRONTOSAURUS) 65 feet long A Plant-eating Dinosaur

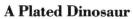

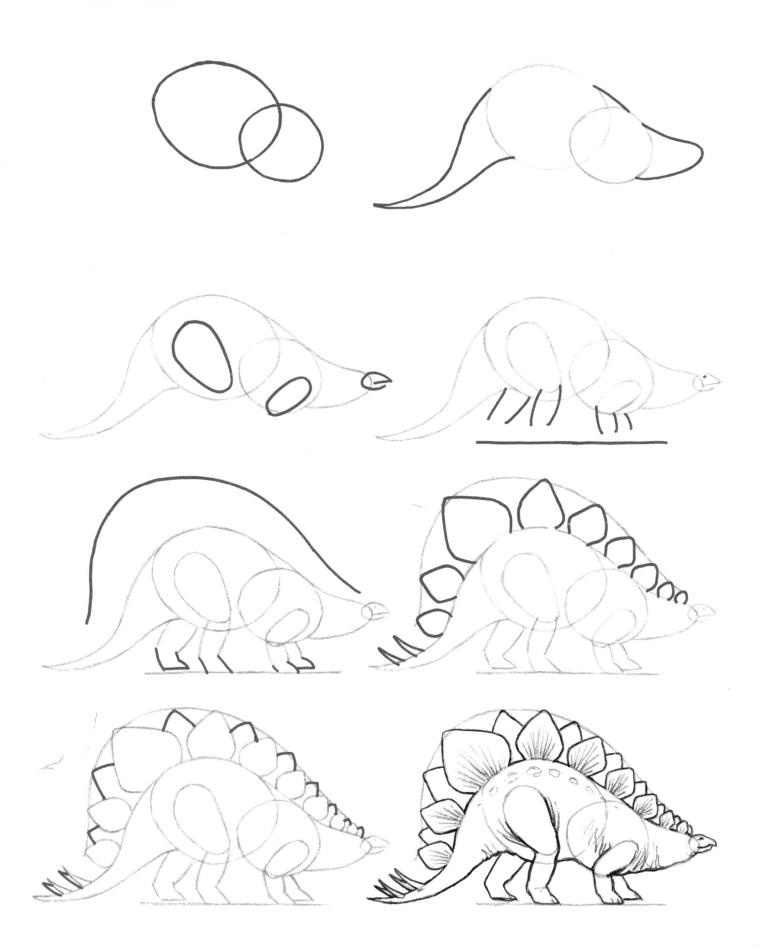

PROTOCERATOPS 6 feet long

An Early Horned Dinosaur

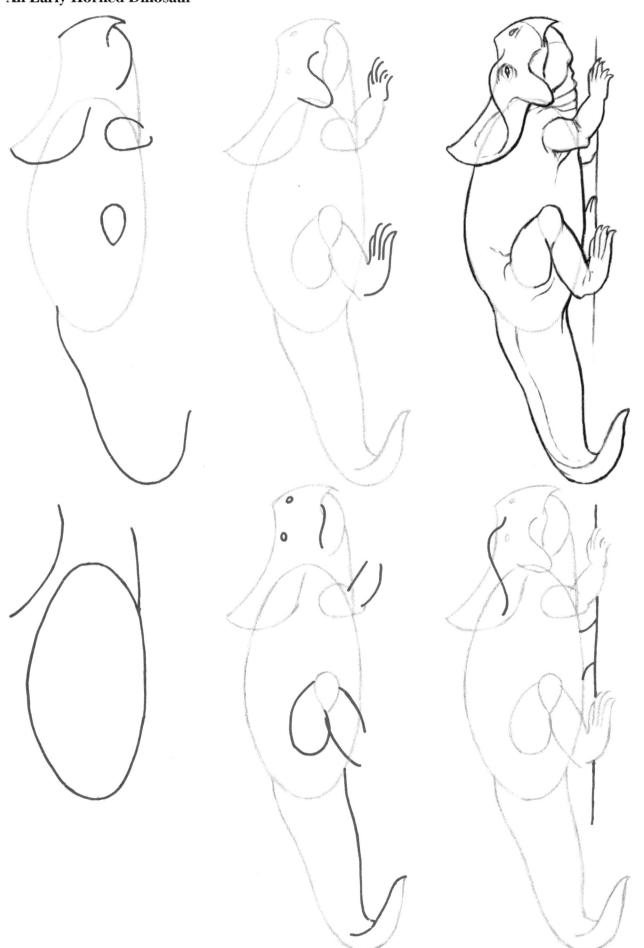

TRICERATOPS 30 feet long

A Plant-eating Horned Dinosaur

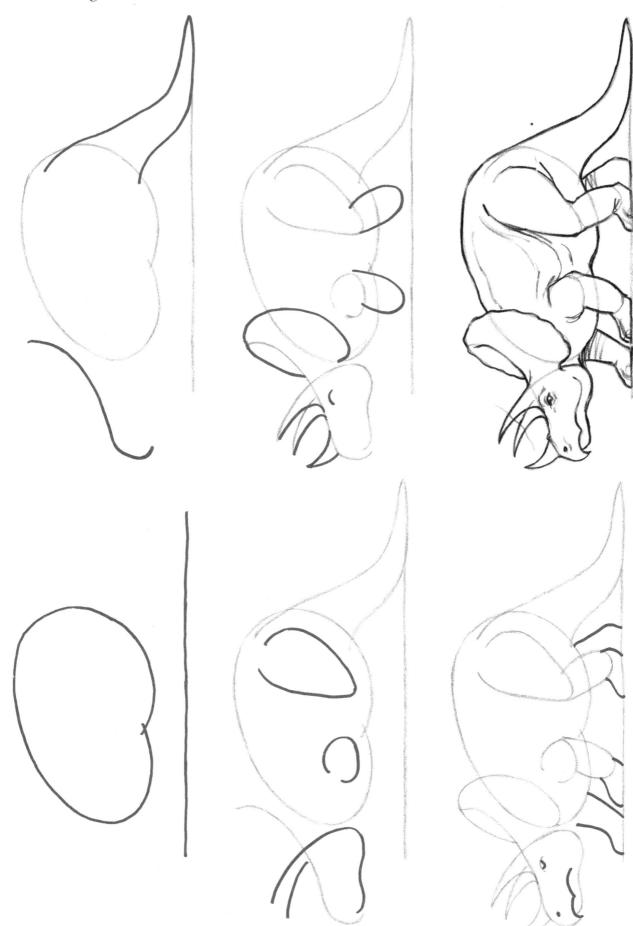

STYRACOSAURUS 16 feet long

A Plant-eating Horned Dinosaur

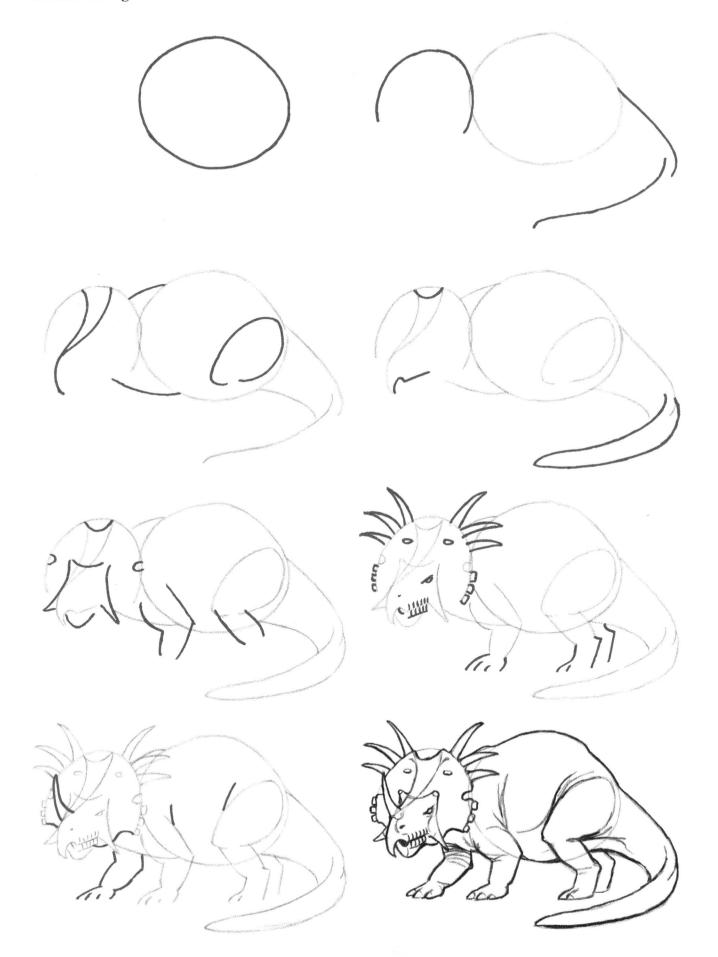

IGUANODON 30 feet long

A Plant-eating Dinosaur

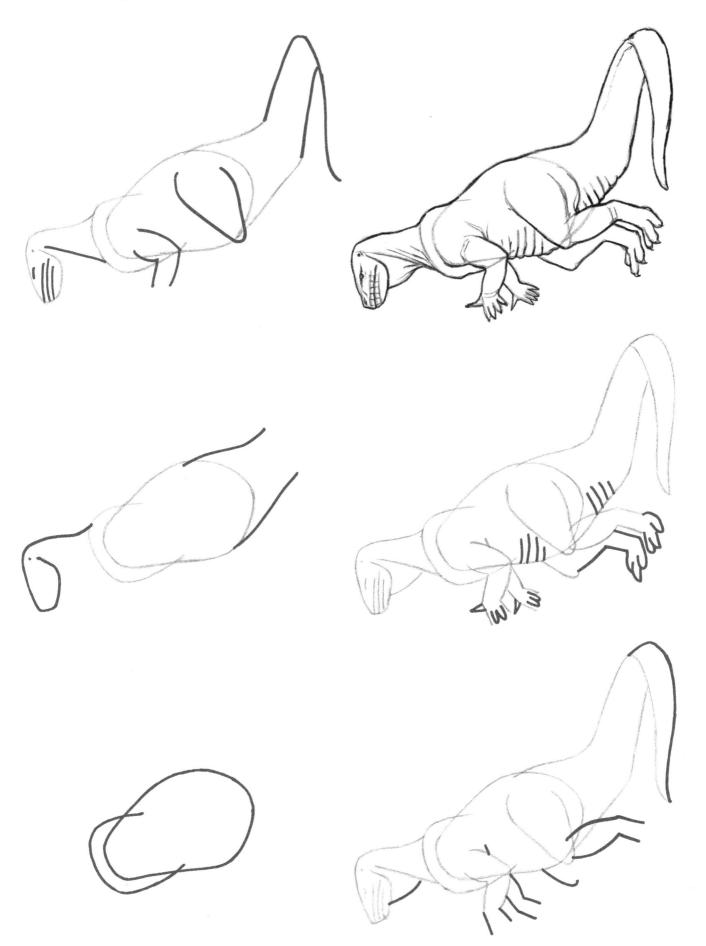

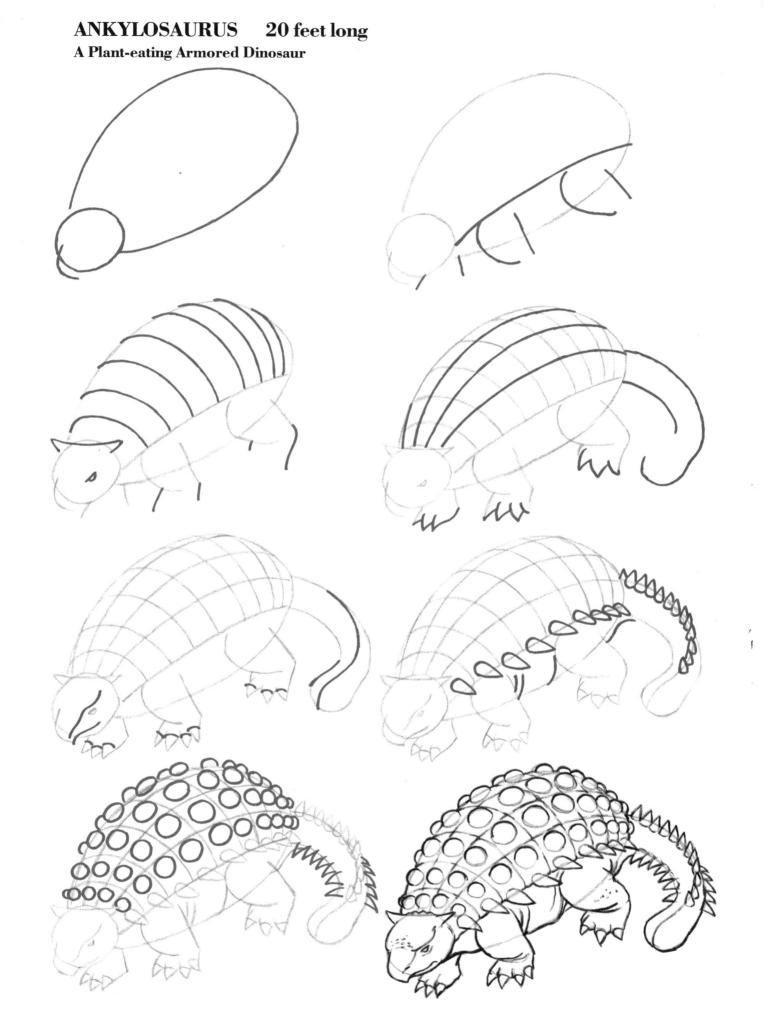

DIPLODOCUS 87 feet long

A Giant Plant-eating Dinosaur

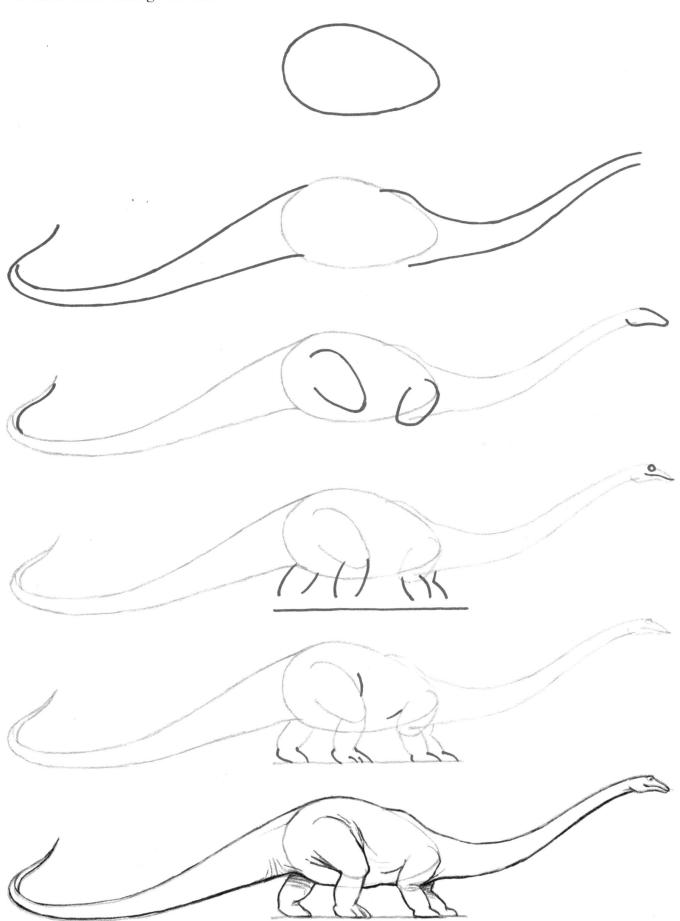

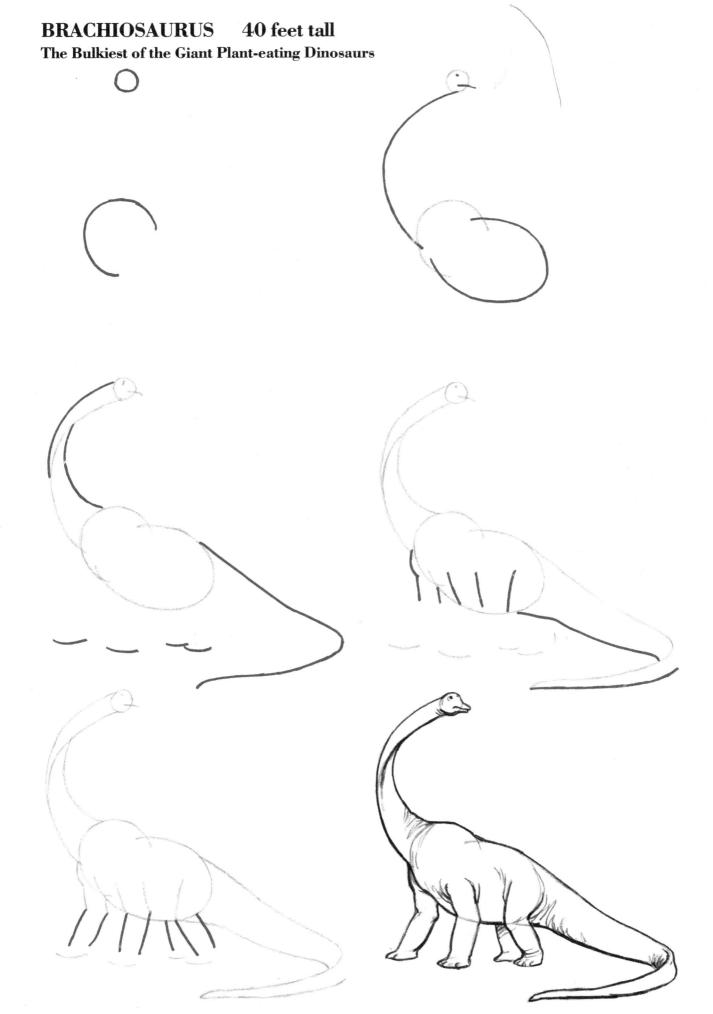

ANATOSAURUS 30 feet long

A Duck-billed Dinosaur

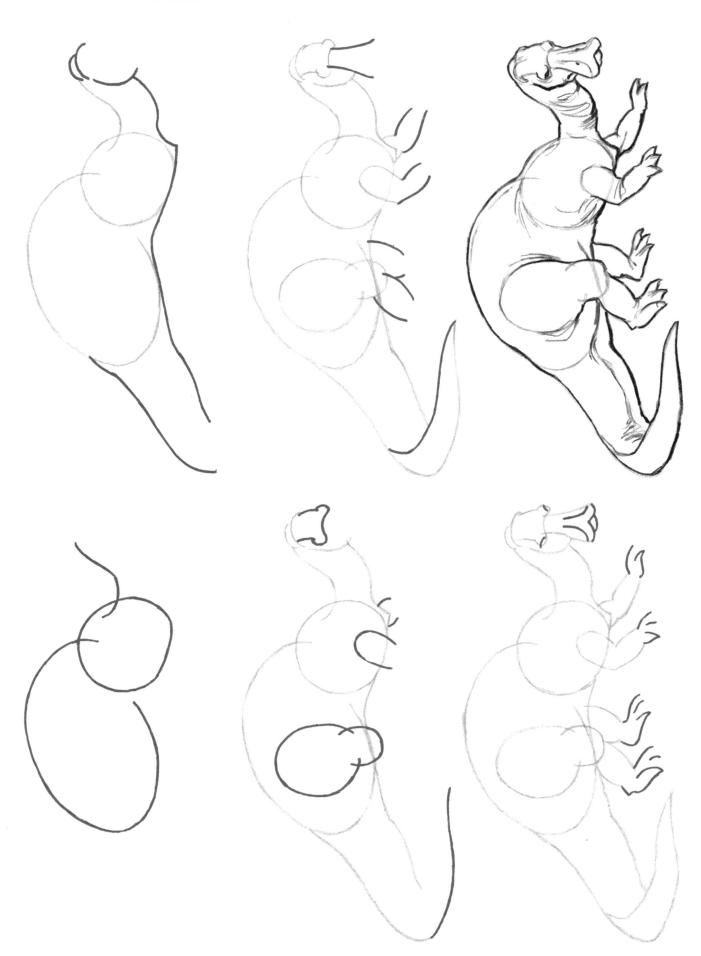

A NAUTILOID 9 feet long

An Ancient Relative of Squids and Octopuses

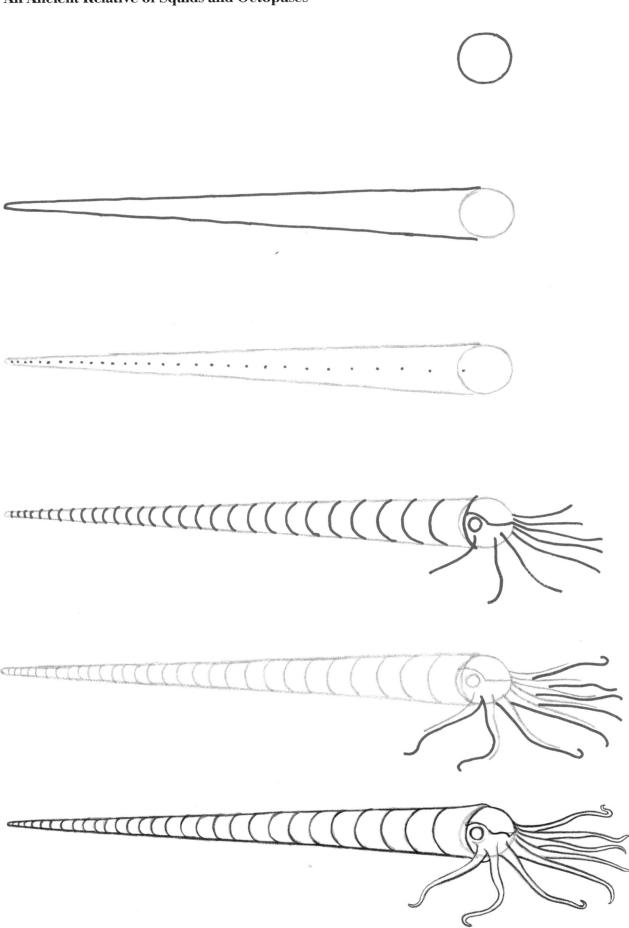

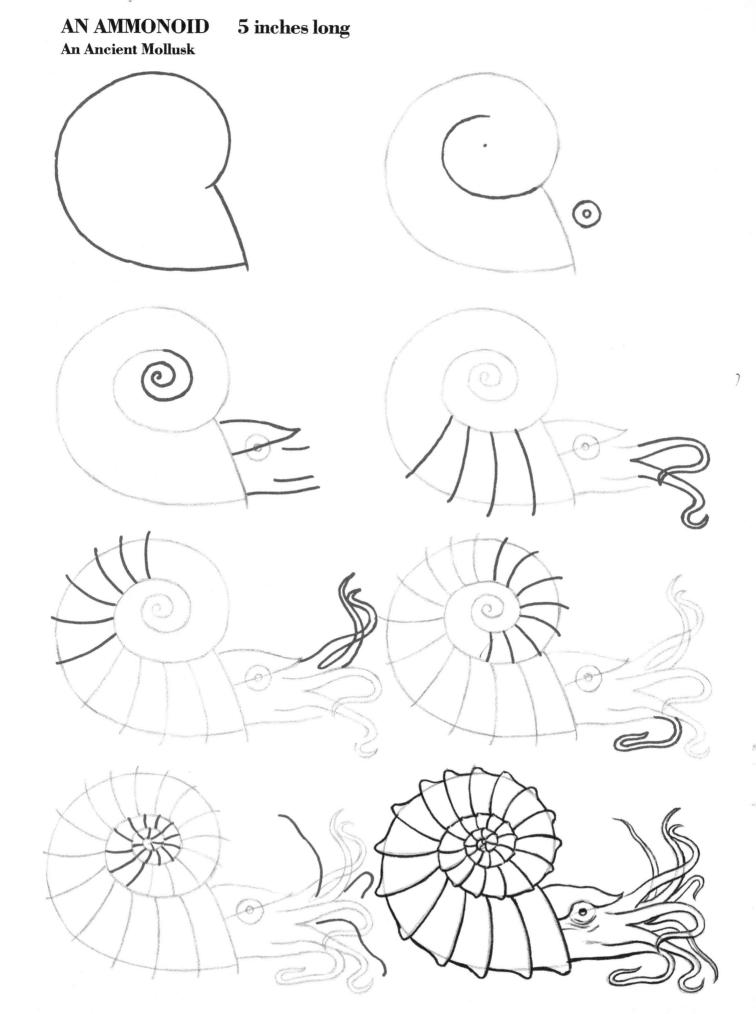

A TRILOBITE 4 inches long

An Ancient Relative of the Crabs, Spiders and Insects

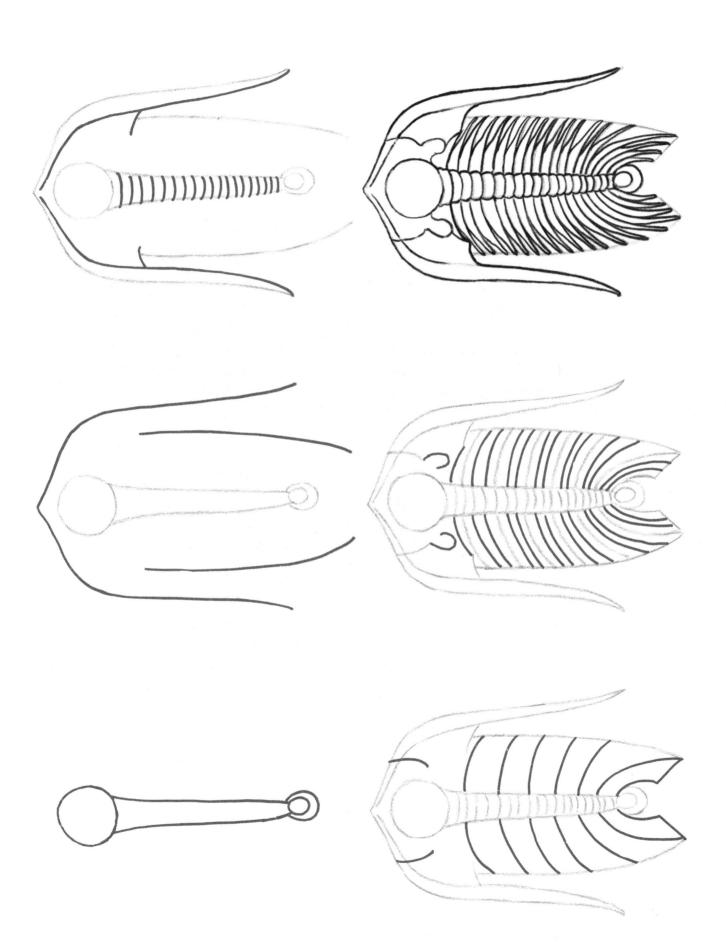

A EURYPTERID 9 feet long

A Seagoing Relative of Scorpions and Spiders

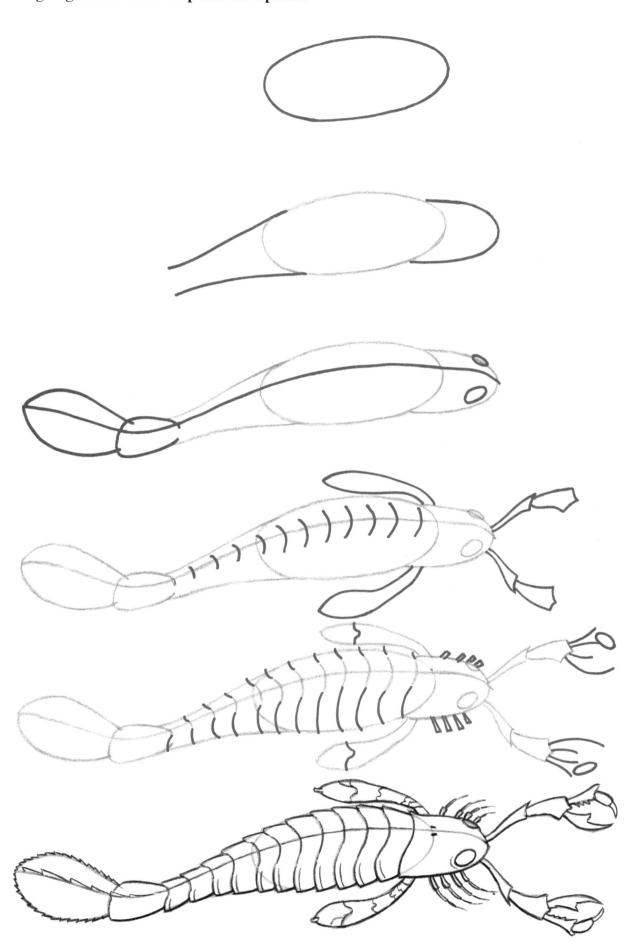

HOLOPTYCHIUS 30 inches long
An Ancient Fish, Ancestor of the Amphibians

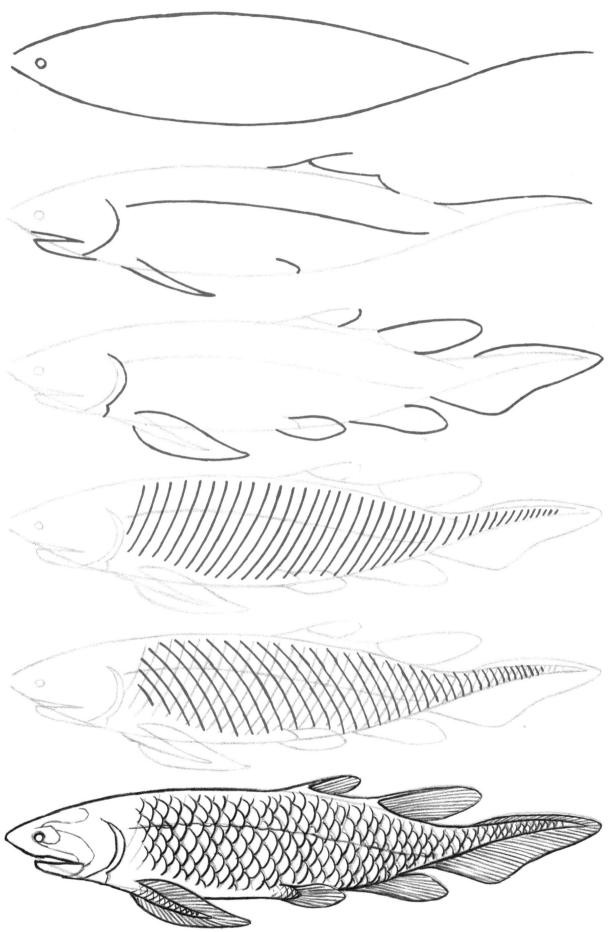

PLEURACANTHUS 7 feet long

A Spiny Fish—Not Related to the Sharks

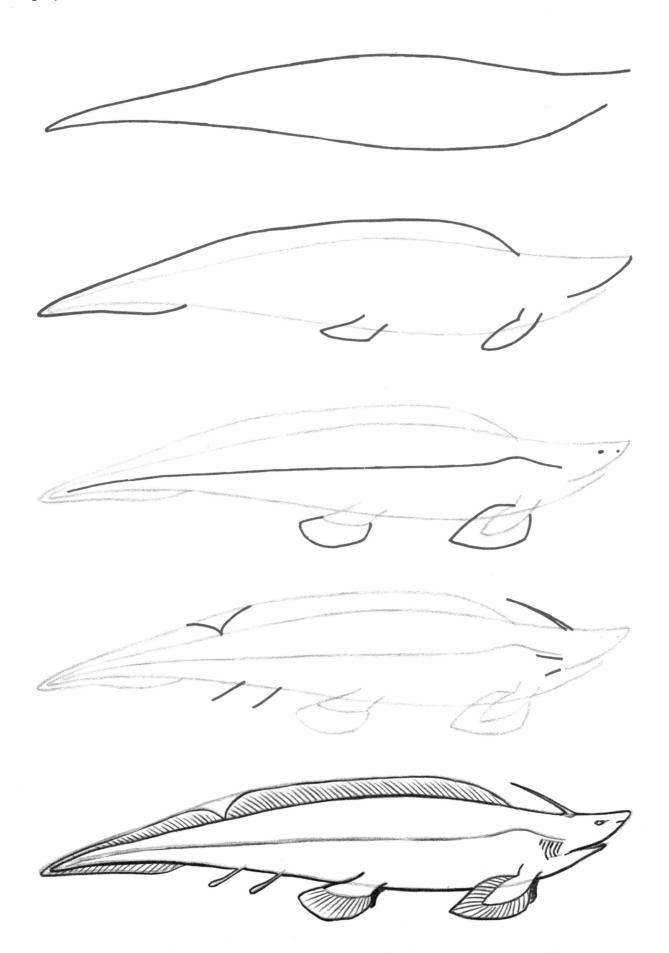

DINICHTHYS 30 feet long

An Ancient Giant Fish

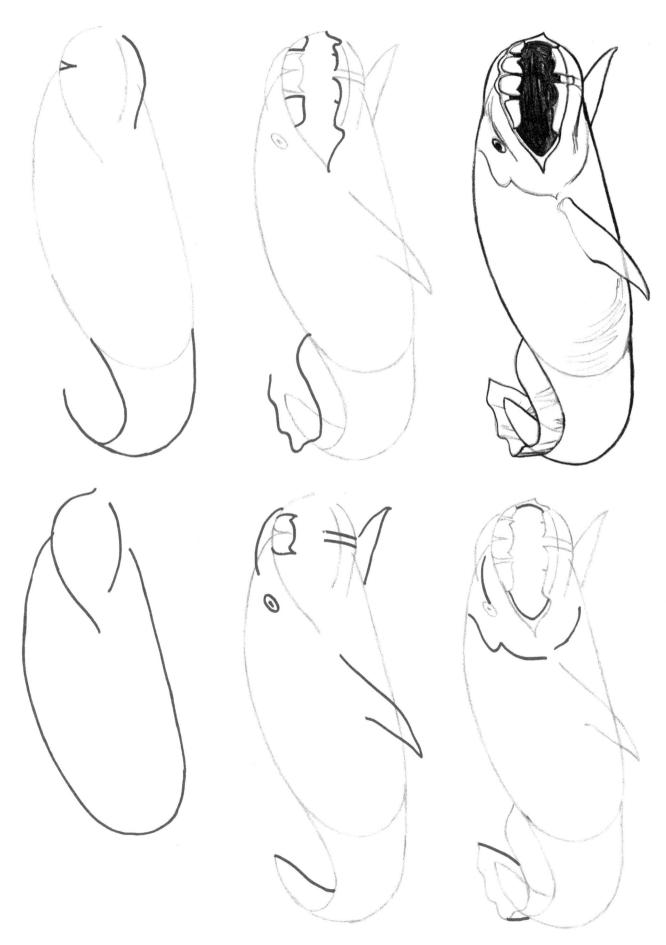

DIPLOCAULUS 2 feet long

An Early Water-living Amphibian

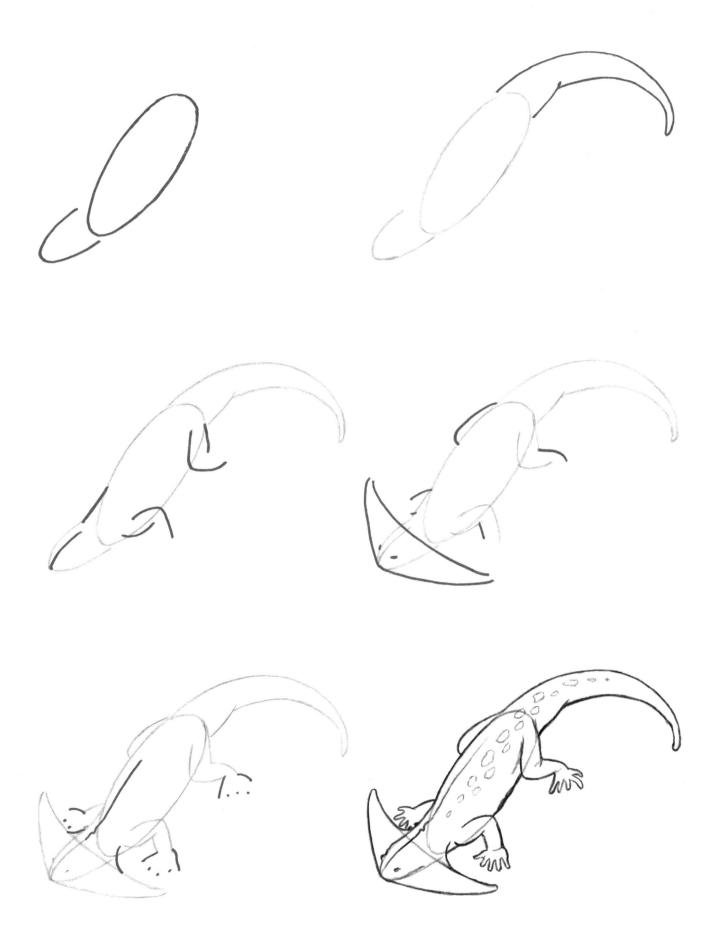

ERYOPS 5 feet long

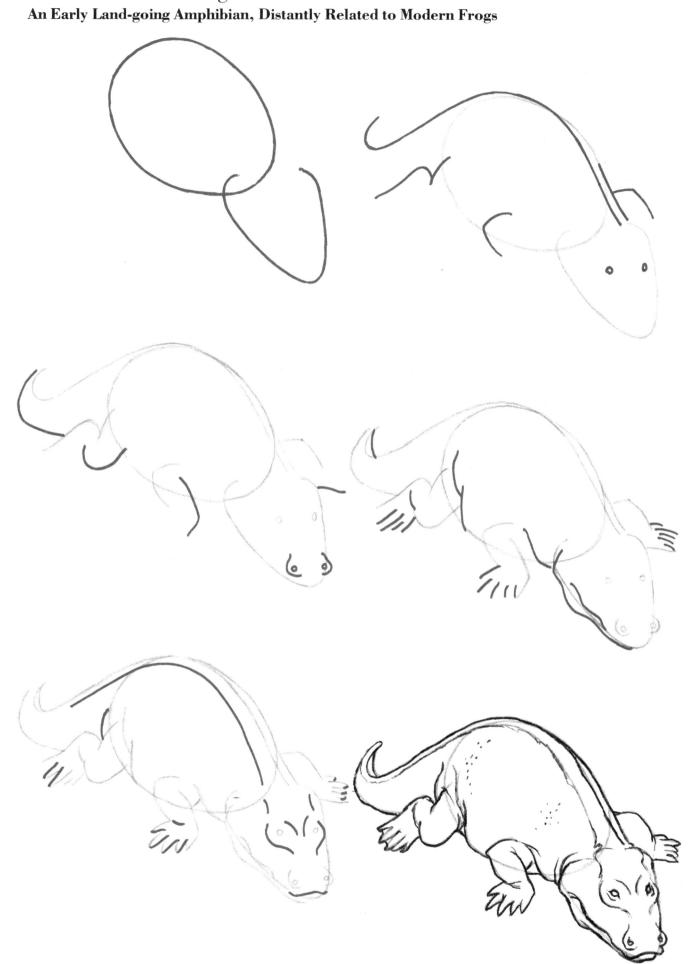

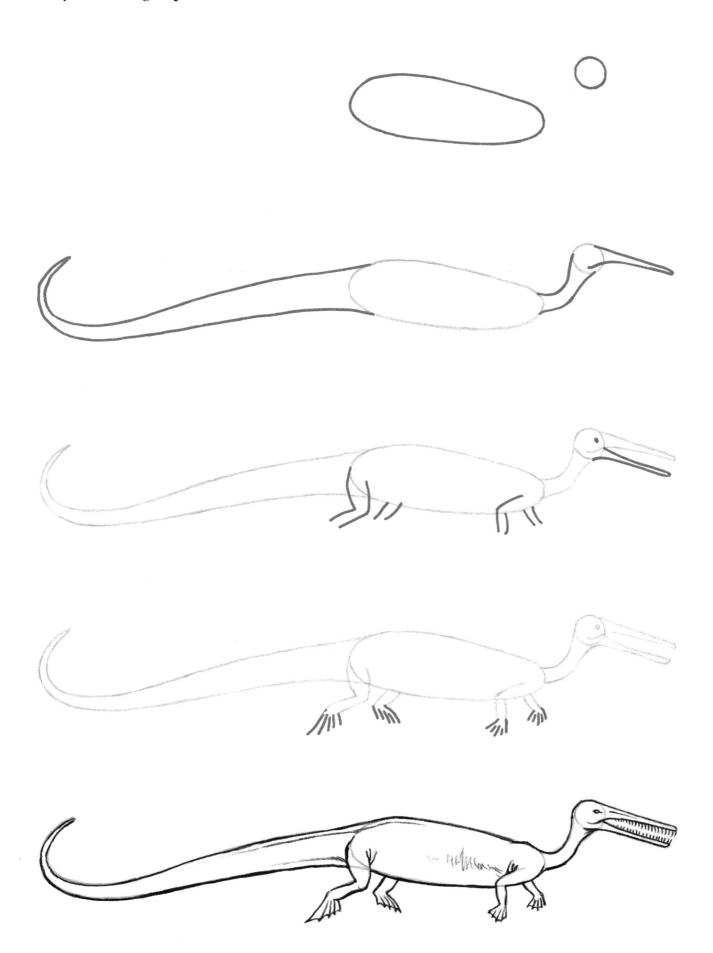

ICHTHYOSAUR 40 feet long

A Seagoing Reptile

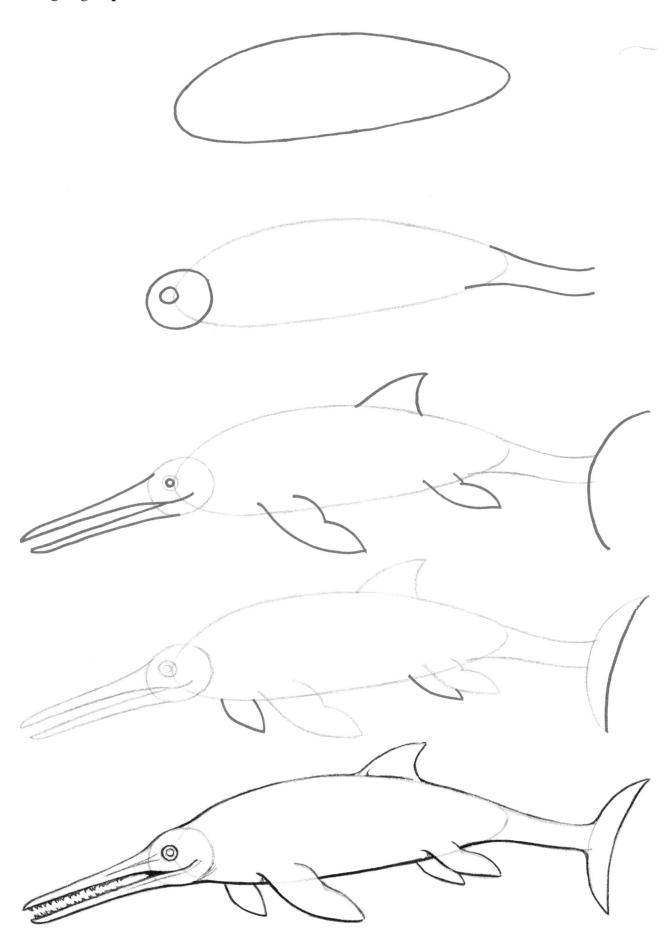

6 feet long **CYNOGNATHUS** A Mammal-like Reptile

TRIMACROMERUM 10 feet long

A Short-necked Seagoing Reptile

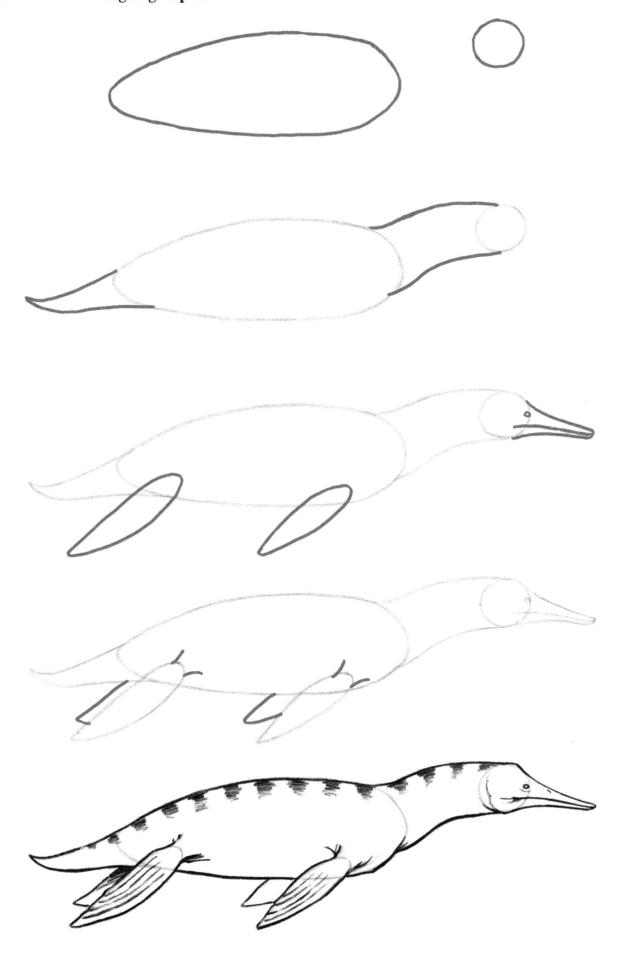

KANNEMEYERIA 6 feet long A Mammal-like Reptile

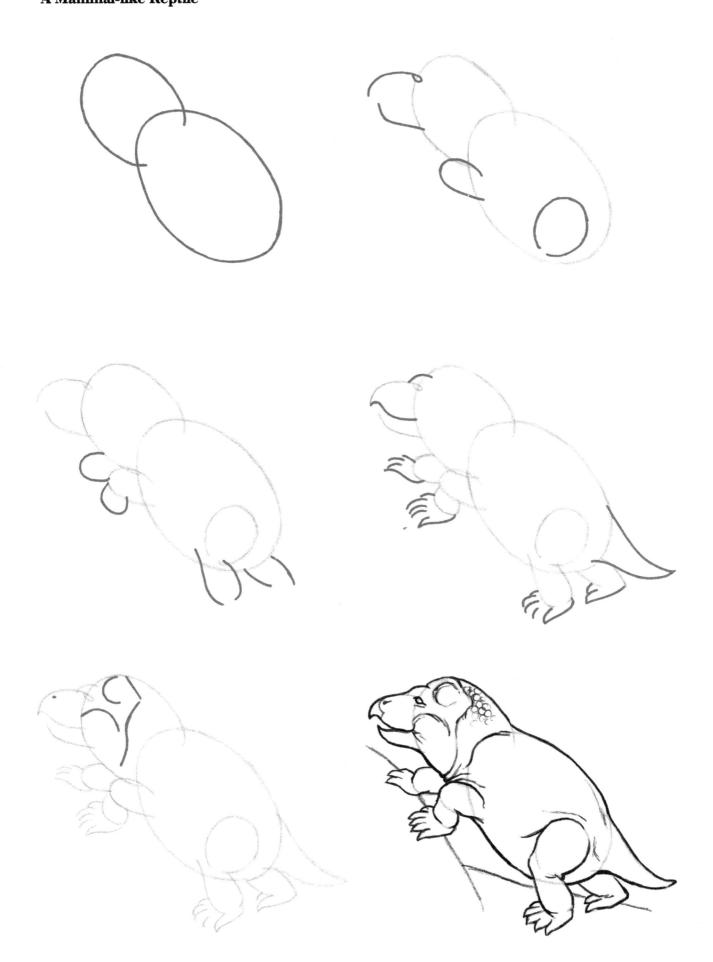

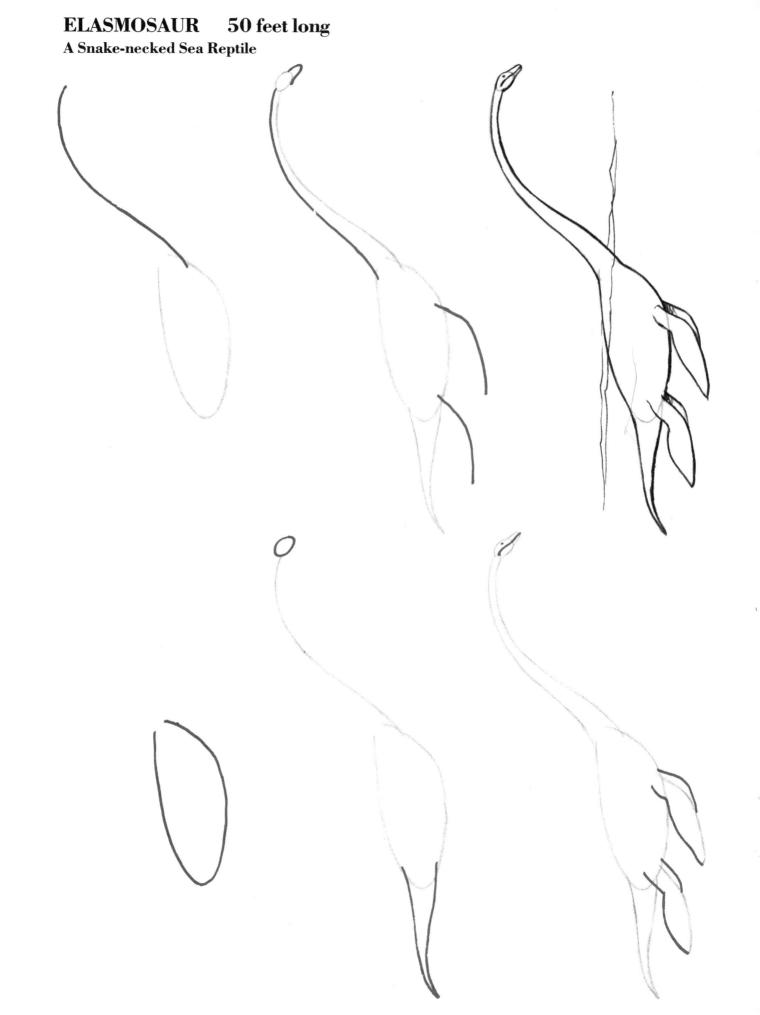

PTERANODON 26 foot wingspread A Tailless Membrane-winged Reptile

MOSASAUR 30 feet long A Seagoing Lizard

DIMETRODON 10 feet long An Early Mammal-like Reptile

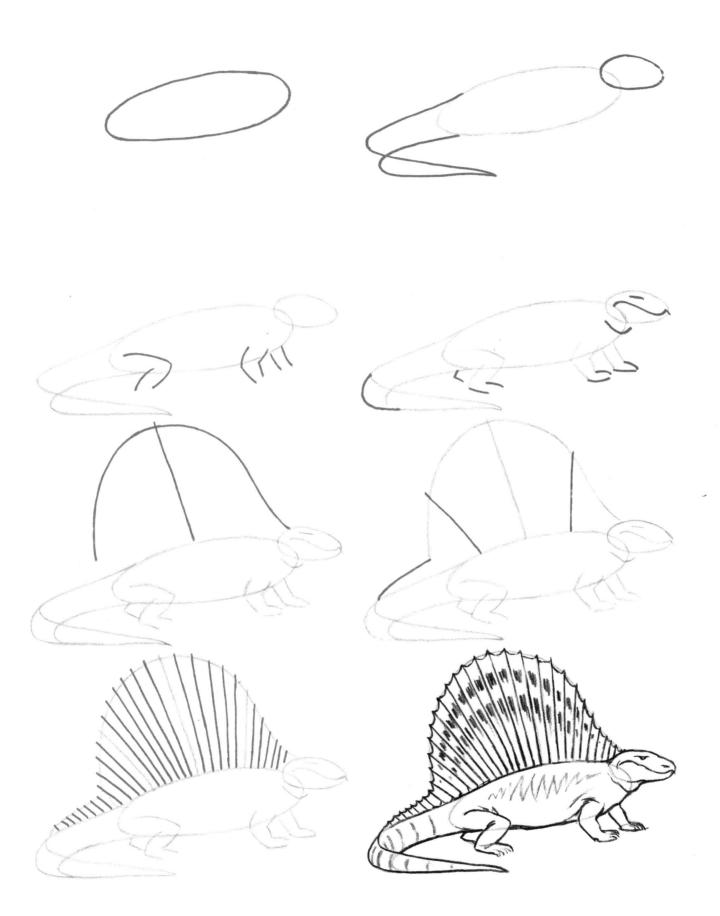

ARCHELON 12 feet long

An Ancient Sea Turtle

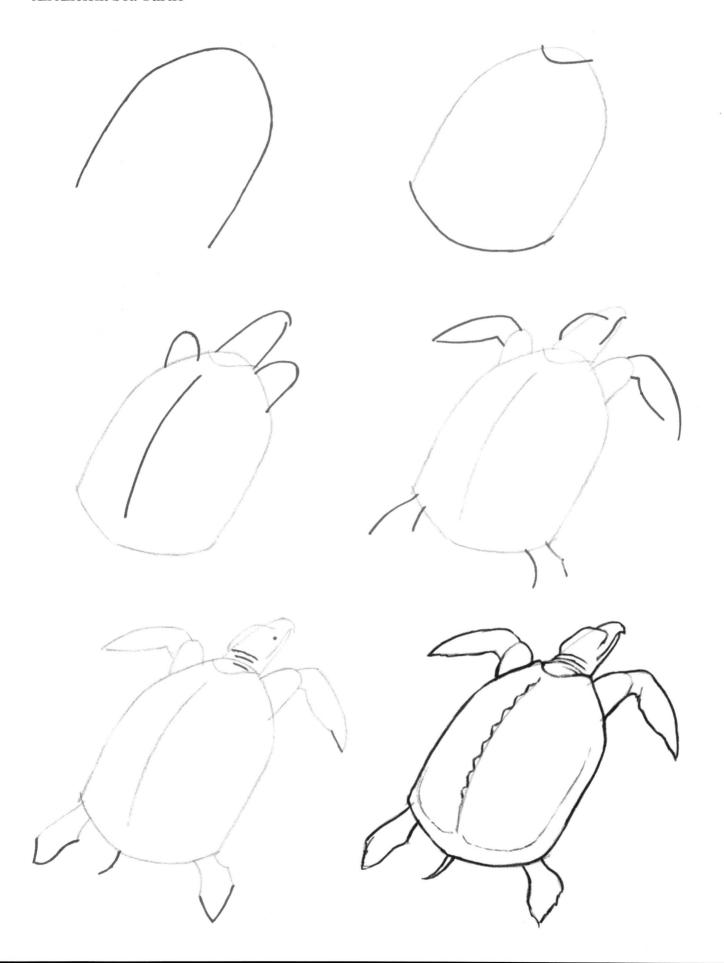

RHAMPHORHYNCHUS 4 feet long

A Membrane-winged Reptile

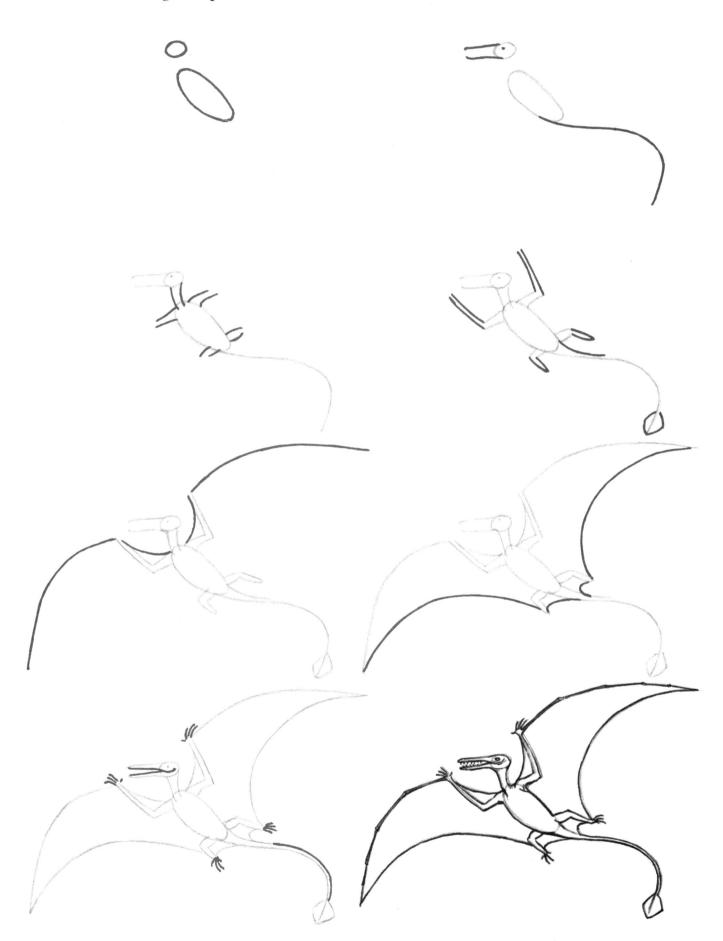

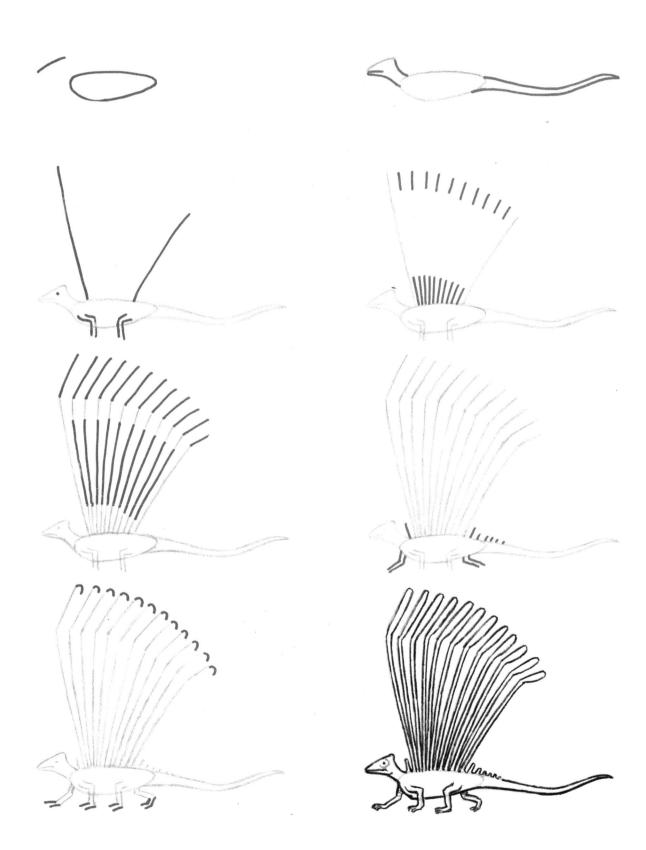

SALTOPOSUCHUS 45 inches long A Two-legged Reptile, Ancestor of Dinosaurs and Birds

MOA 10 feet tall
A Giant Flightless Bird of New Zealand

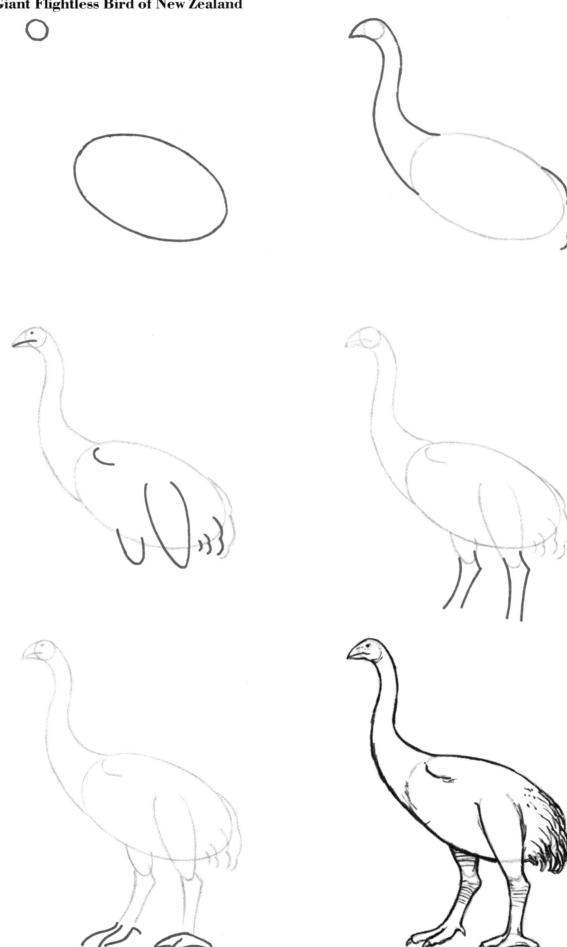

A Primitive Toothed Diving Bird

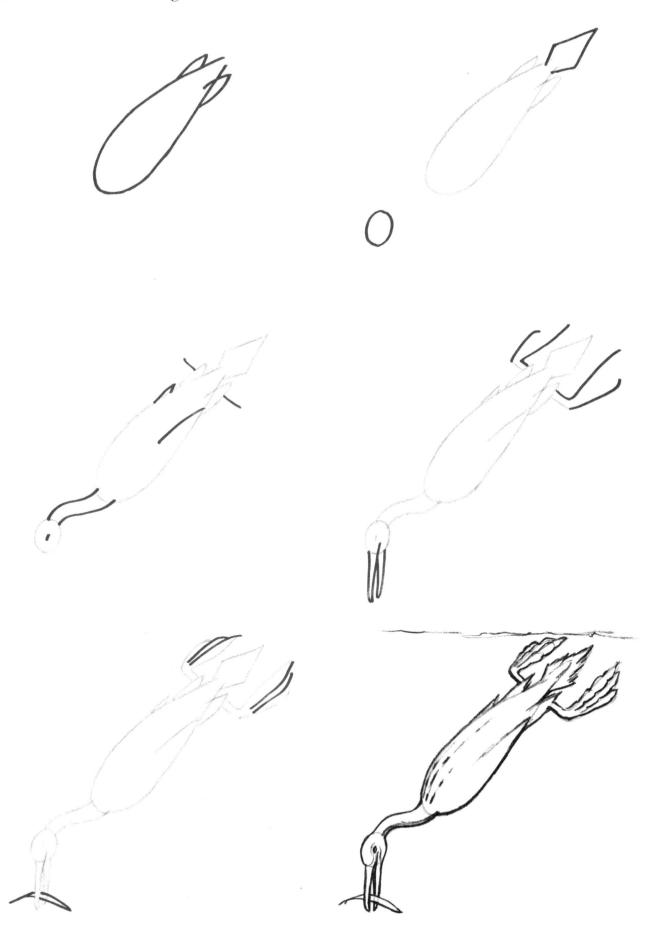

ARCHAEOPTERYX 15 inches long The First Bird

DIATRYMA 7 feet tall
A Meat-eating Giant Flightless Bird

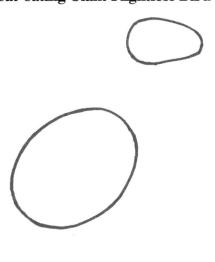

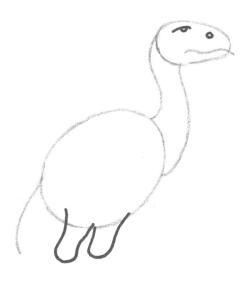

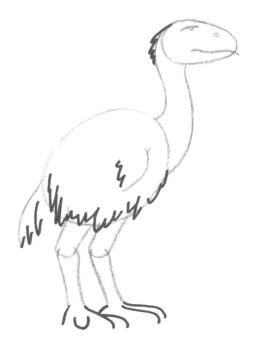

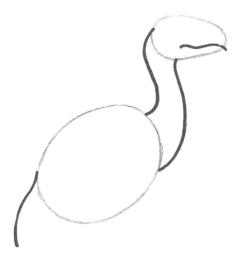

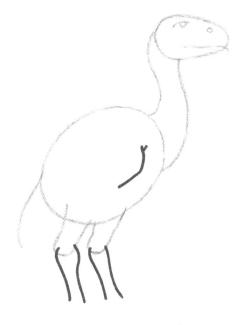

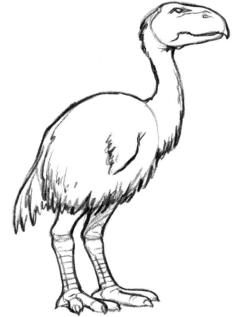

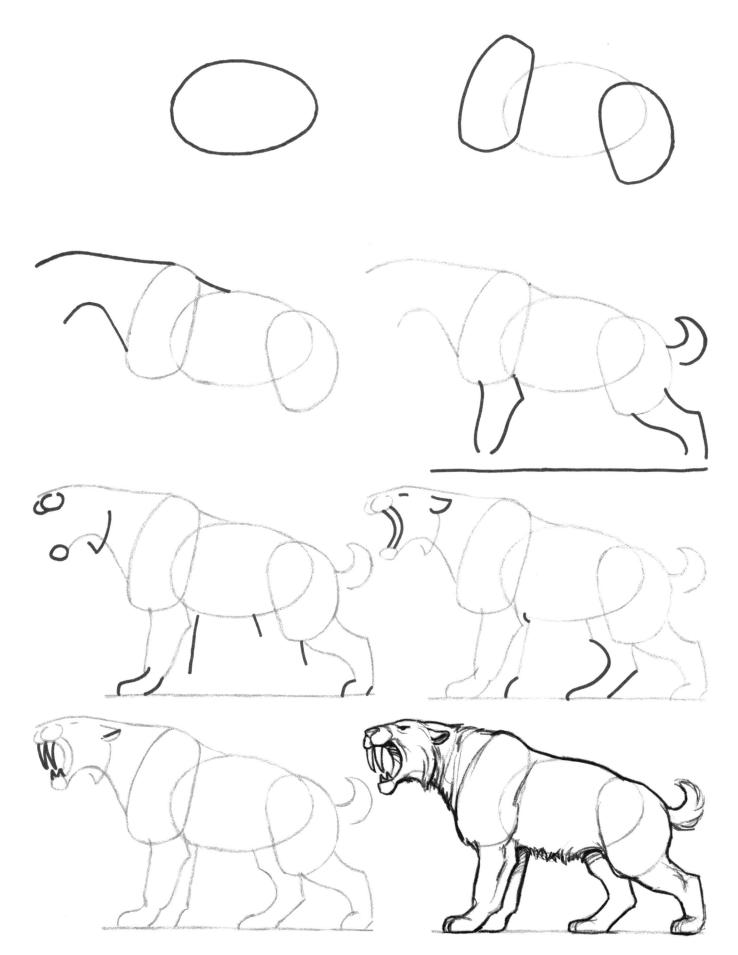

GLYPTODON 9 feet long
An Ancient Relative of the Armadillo

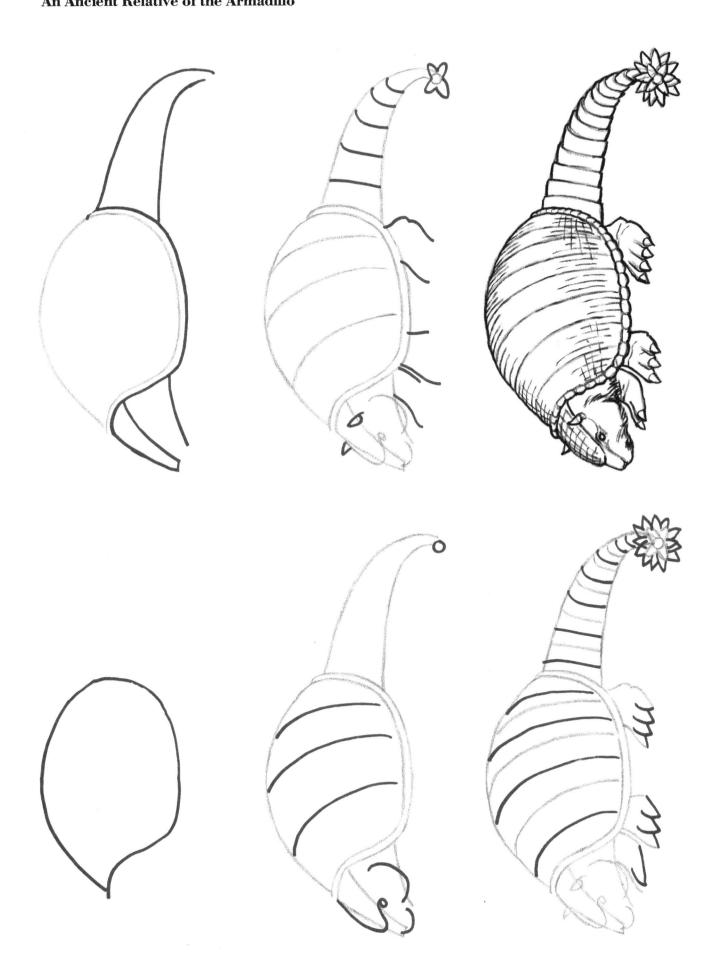

MEGALOCEROS 11 feet across the antlers

The Giant Elk of the Ice Age

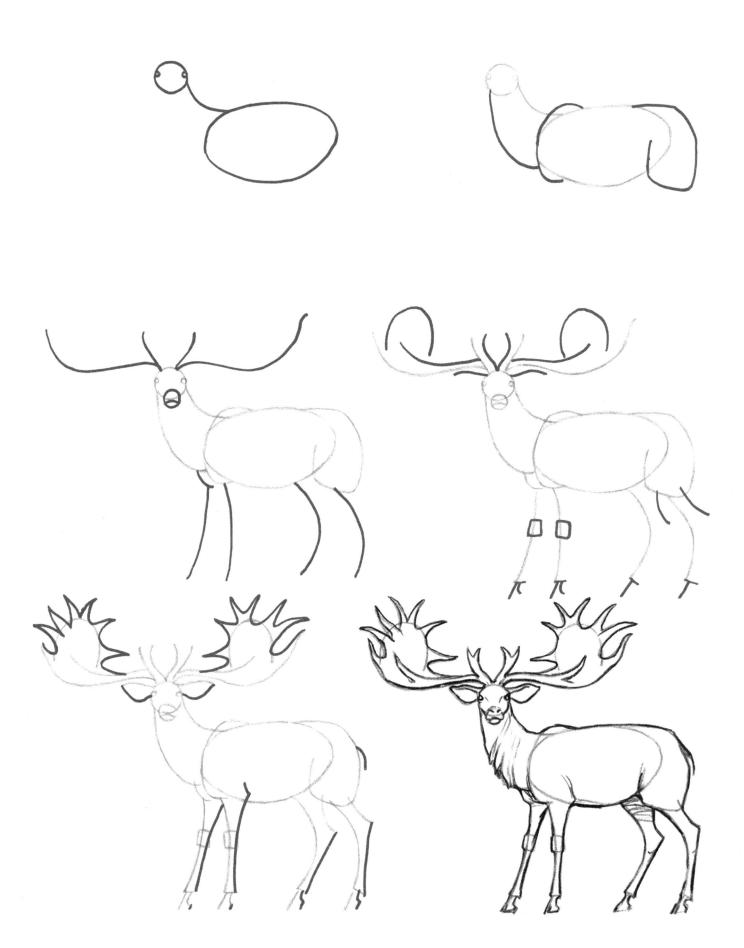

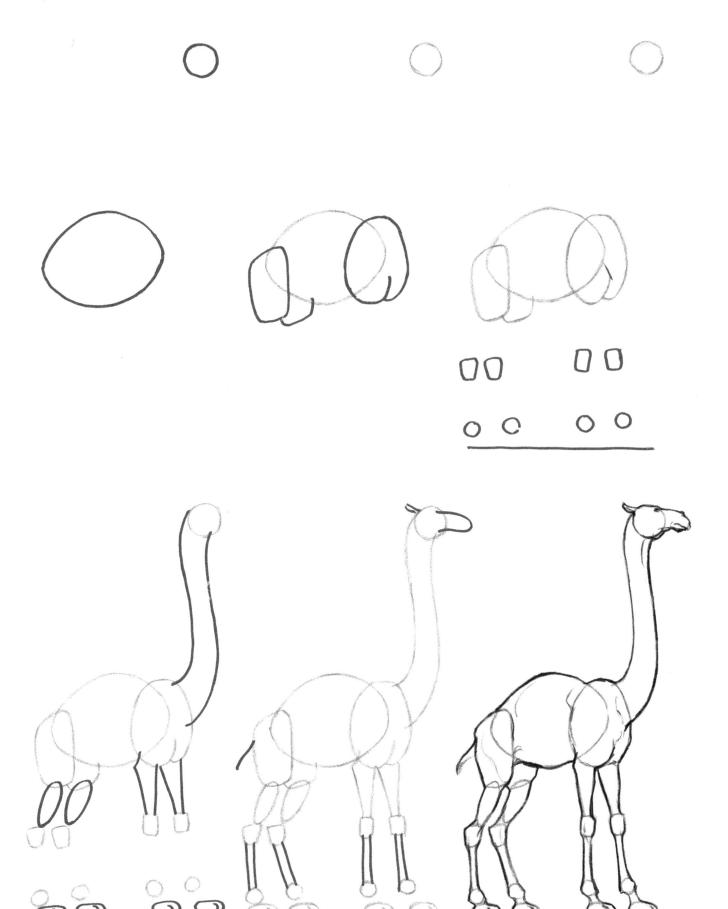

BALUCHITHERIUM 25 feet long

An Ancient Hornless Rhinoceros

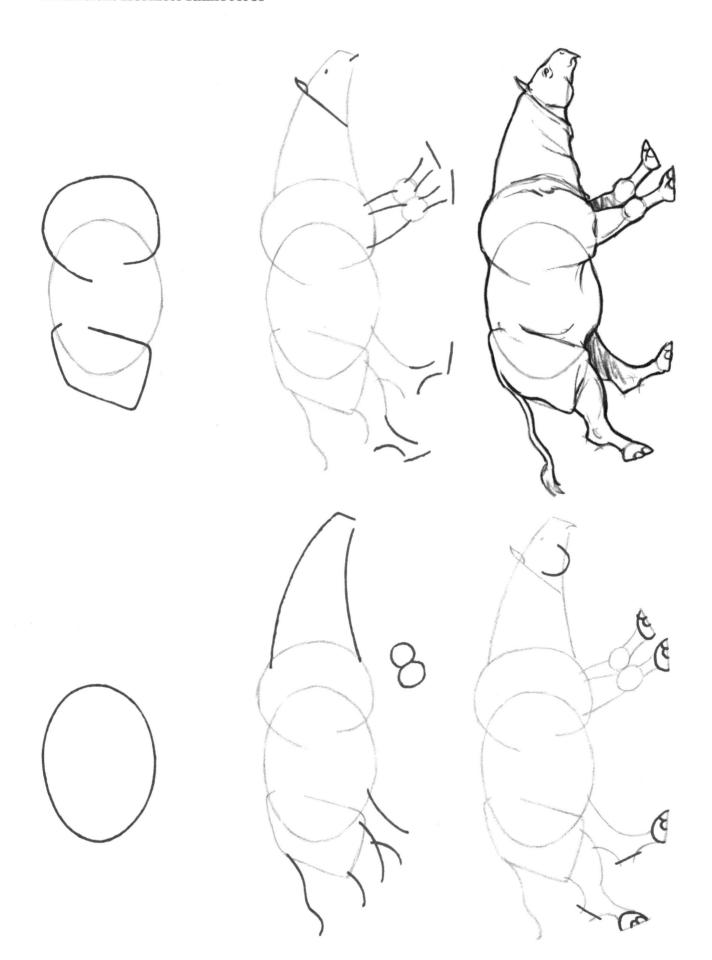

WOOLLY MAMMOTH 10 feet tall

An Ice Age Elephant

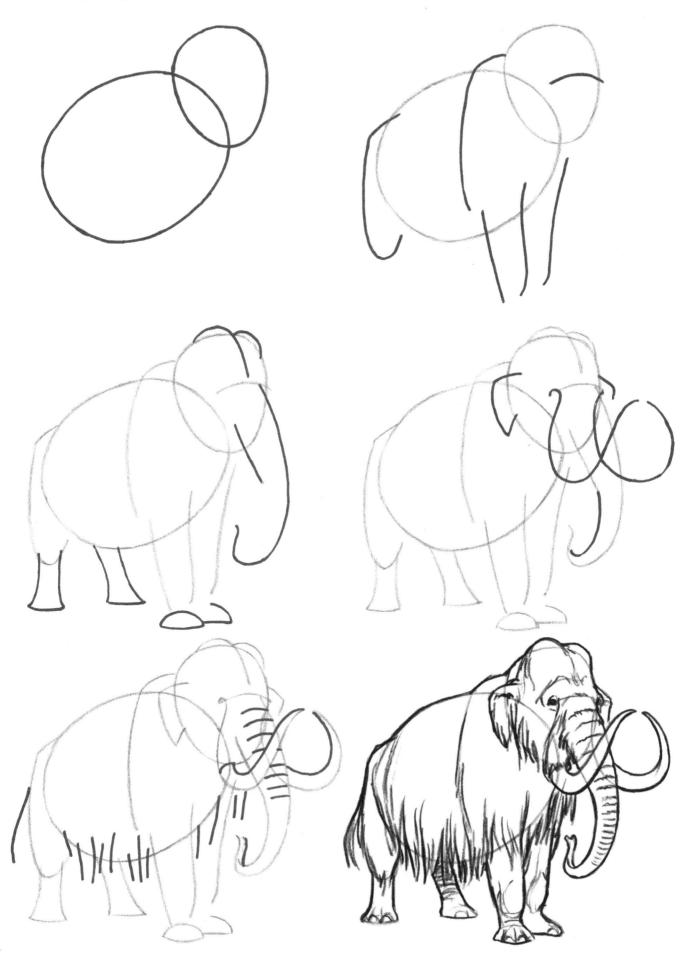

ZEUGLODON 65 feet long

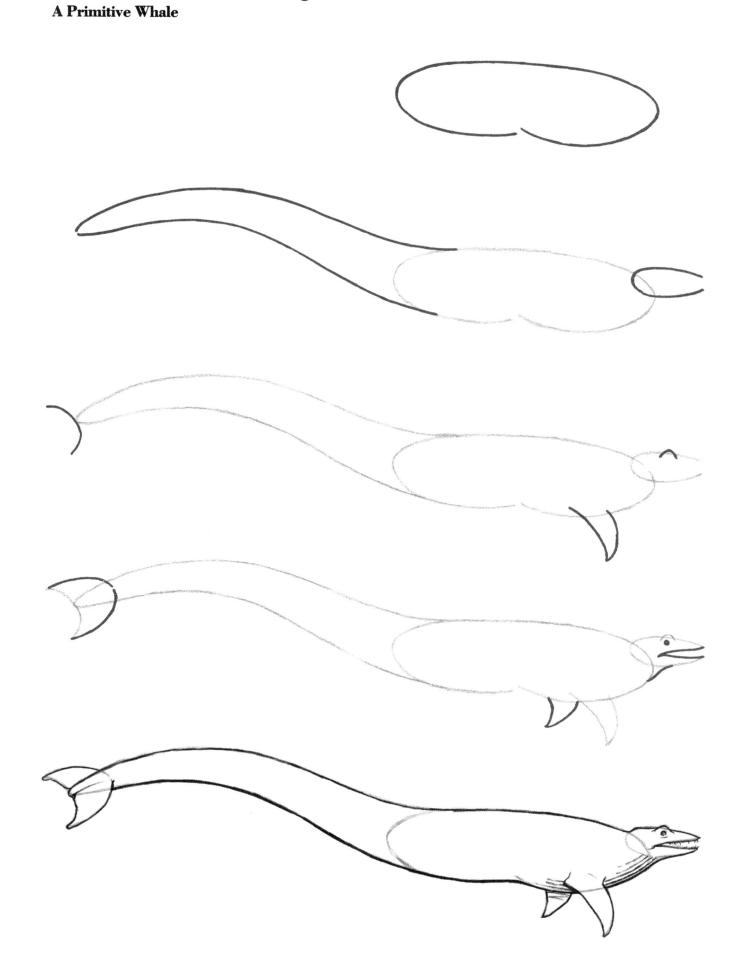

BRONTOTHERIUM 15 feet long

An Early Hoofed Mammal, Related to Horses and Rhinoceroses

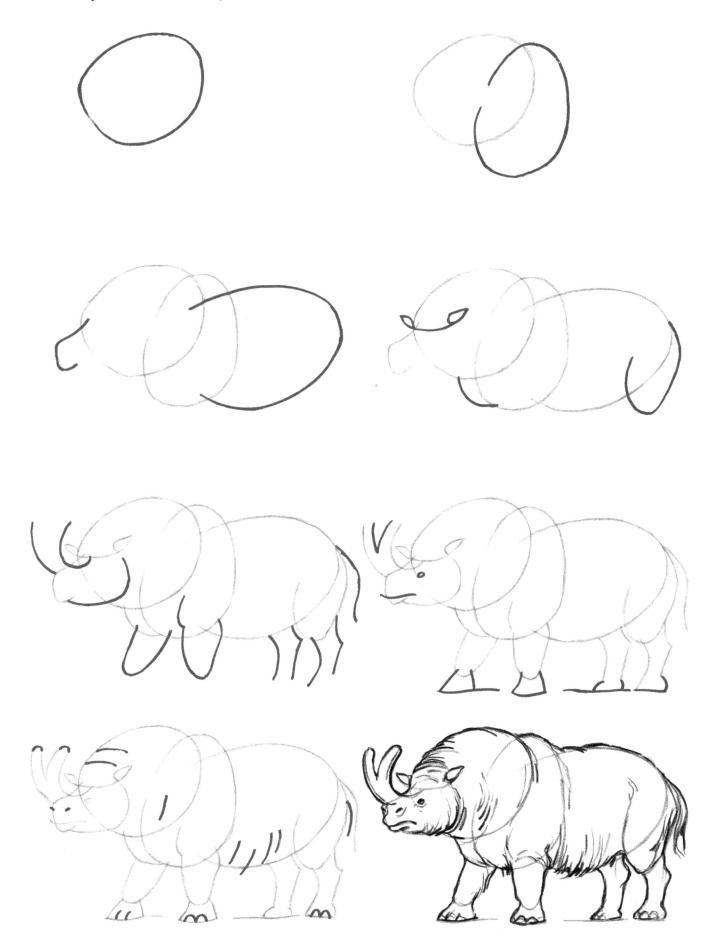

MEGATHERIUM 25 feet long

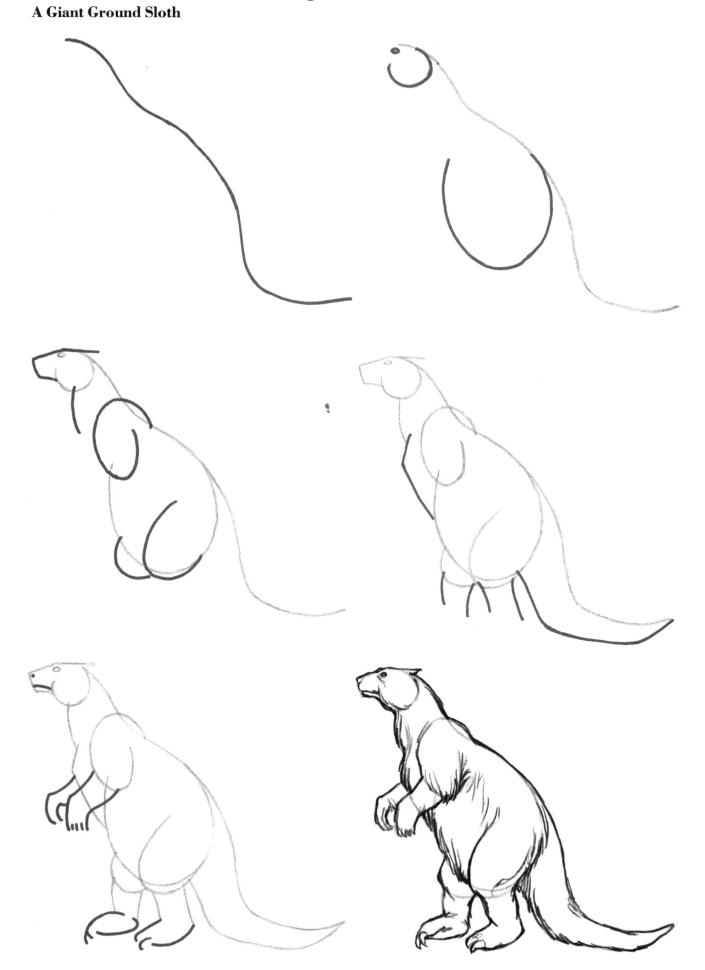

$HYRACOTHERIUM \, (formerly \, EOHIPPUS) \qquad 1\frac{1}{2} \, feet \, long$

The Ancestor of the Horse

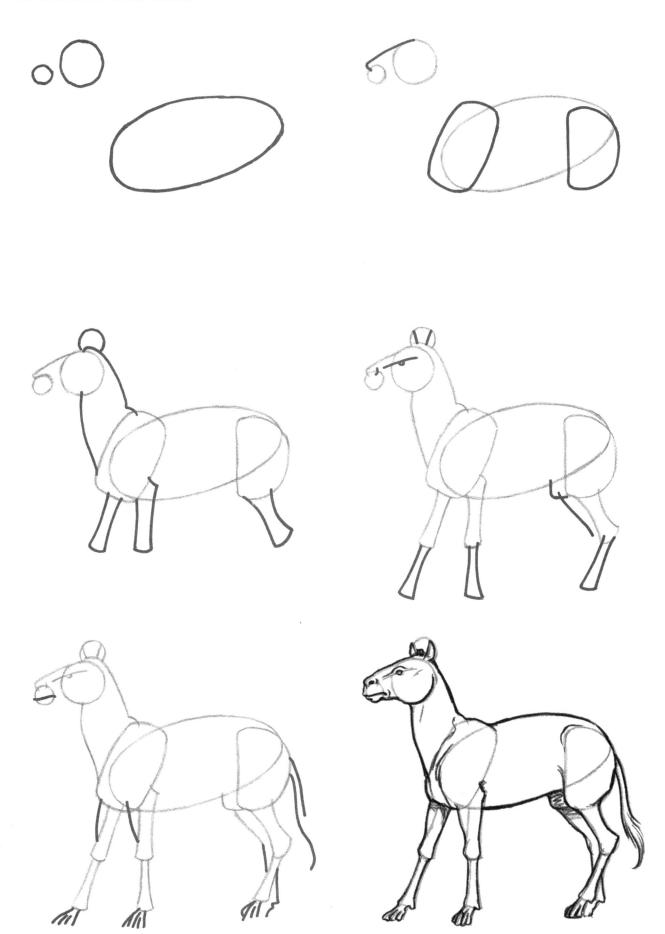

COELODONTA 12 feet long

The Woolly Rhinoceros of the Ice Ages

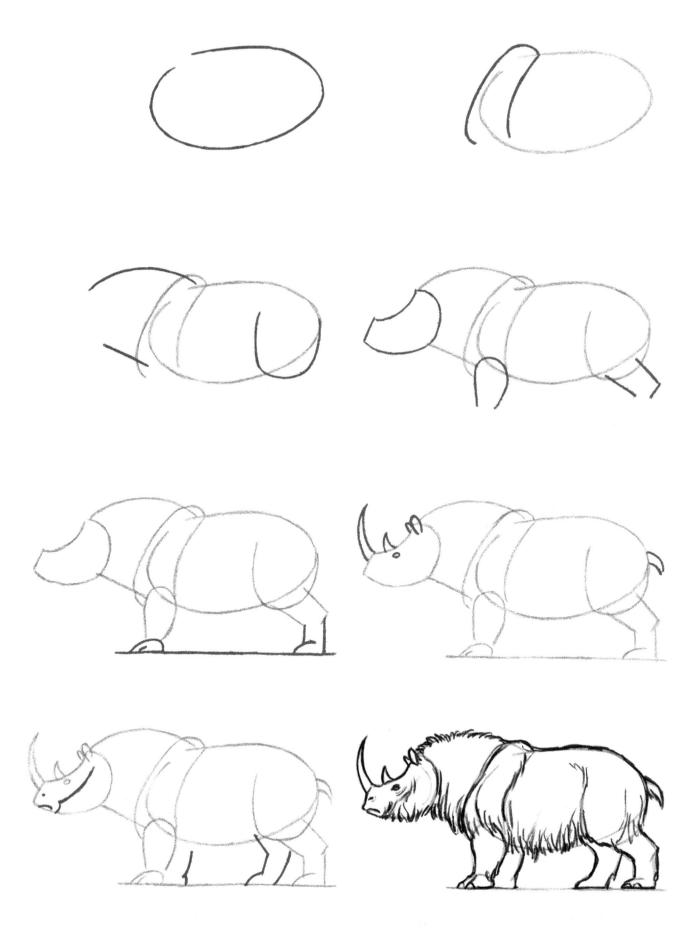

Lee J. Ames began his career at the Walt Disney Studios, working on films that included Fantasia and Pinocchio. He taught at the School of Visual Arts in Manhattan, and at Dowling College on Long Island, New York. An avid worker, Ames directed his own advertising agency, illustrated for several magazines, and illustrated approximately 150 books that range from picture books to postgraduate texts. He resided in Dix Hills, Long Island, with his wife, Jocelyn, until his death in June 2011.

DRAW 50 DINOSAURS AND OTHER PREHISTORIC ANIMALS

Experience All That the Draw 50 Series Has to Offer!

With this proven, step-by-step method, Lee J. Ames has taught millions how to draw everything from amphibians to automobiles. Now it's your turn! Pick up the pencil, get out some paper, and learn how to draw everything under the sun with the Draw 50 series.

Also Available:

- · Draw 50 Animal 'Toons
- · Draw 50 Animals
- · Draw 50 Athletes
- · Draw 50 Baby Animals
- Draw 50 Cars, Trucks, and Motorcycles
- Draw 50 Cats
- · Draw 50 Dogs
- Draw 50 Famous Cartoons
- Draw 50 Flowers, Trees, and Other Plants
- · Draw 50 Horses
- · Draw 50 Monsters
- · Draw 50 People
- Draw 50 Princesses
- Draw 50 Sharks, Whales, and Other Sea Creatures
- · Draw 50 Vehicles
- · Draw the Draw 50 Way

1			
i			
8			
L-			
4			